Three week loan
late return of this item will incur fines.
renew online: http://www.arts.ac.uk/library
renew by phone: 020 7514 9690

BP PORTRAIT AWARD 2009

National Portrait Gallery

Published in Great Britain by
National Portrait Gallery Publications,
National Portrait Gallery,
St Martin's Place, London WC2H 0HE

Published to accompany the BP Portrait
Award 2009, held at the National Portrait
Gallery, London from 18 June to 20
September 2009, Southampton City Art
Gallery, from September to November
2009 and the Scottish National Portrait
Gallery, from December 2009 to
January 2010.

For a complete catalogue of current
publications please write to the address
above, or visit our website at
www.npg.org.uk/publications

ISBN 978 1 85514 403 3

A catalogue record for this book is
available from the British Library.

Head of Publications: Celia Joicey
Editor: Claudia Bloch
Design: October Design
Production Manager: Ruth Müller-Wirth
Photography: Prudence Cuming
Printed and bound in Italy
Cover: *Georgie* by Mary Jane Ansell

WITHDRAWN

Supported by BP

Mixed Sources

Product group from well-managed
forests and other controlled sources
www.fsc.org Cert no. DNV-COC-000117
© 1996 Forest Stewardship Council

CONTENTS

DIRECTOR'S FOREWORD 6
Sandy Nairne

SPONSOR'S FOREWORD 7
Tony Hayward

PAINTING BENEATH THE SKIN 8
Sarah Dunant

BP PORTRAIT AWARD 2009 15

PRIZEWINNING PORTRAITS 16
Peter Monkman 17
Michael Gaskell 18
Annalisa Avancini 19
Mark Jameson 20

SELECTED PORTRAITS 21

BP TRAVEL AWARD 2008 74
Emmanouil Bitsakis

ACKNOWLEDGEMENTS 79

PICTURE CREDITS 79

INDEX 80

DIRECTOR'S FOREWORD

What makes a painted portrait particular or special? And which are the very best of the more than 1,900 works submitted? These questions came up again and again throughout the two days of judging the 2009 BP Portrait Award. Something distinctive in the interaction of sitter and artist is expected, offering character, personality, mood or emotion. Likeness may be central, however, for the vast majority of the submitted portraits, the subject is known closely to the artist but not to the judges. Yet the look of the sitter, whether posed or captured informally, painted with expressive brushstrokes or in a highly polished photorealist style, needs to be compelling – to draw our attention and to offer a connection with the person portrayed.

Painted portraits are highly crafted and captivating objects – testimony to the individual or group they depict (created to last beyond present lives) and the determining skill of the artist. The pose of the sitter and the construction of the whole image matter greatly. These portraits carry the effort and diligence of their making, whether through painterly impasto brushwork, a detailed and finely honed technique or through complex layers of oil or acrylic. The recently unveiled and outstanding portraits of Sir Peter Mansfield and Camila Batmanghelidjh by BP Portrait Award First Prize winners Stephen Shankland (b.1971, winner 2004) and Dean Marsh (b.1968, winner 2005) both demonstrate the power of creative interaction between artist and subject, combined with meticulous technical finesse. Such portraits represent distinguished sitters but also stand for the very best of portrait painting today.

I am enormously grateful to BP for their continued support – now in its twentieth year – of the competition, exhibition and the Travel Award. This collaboration is an outstanding example of sponsorship making a real difference to the arts in Britain, and my sincere thanks go to the company and to Tony Hayward, Group Chief Executive.

Sandy Nairne
Director, National Portrait Gallery

SPONSOR'S FOREWORD

The National Portrait Gallery is home to the world's largest collection of portraits, and BP is delighted to support the BP Portrait Award, now in its twentieth year.

This year's Award attracted a record 1,901 entries from 54 countries. I would like to thank and congratulate all those who entered; it is their enthusiasm and talent that has enabled the BP Portrait Award to grow in popularity each year, both in terms of entries and audience figures.

I would also like to thank everyone at the National Portrait Gallery for making the BP Portrait Award such a success, for enabling free public access to excellence in the arts, and for providing opportunities for artists to gain exposure and recognition. The selection of portraits on display highlights the tremendous talent that the Award uncovers.

Tony Hayward
Group Chief Executive, BP

PAINTING BENEATH THE SKIN

The woman was dead from childbirth by the time the frescoes were unveiled. When you stand in the main chapel of Santa Maria Novella in Florence, your head spinning with the brilliant vision of Domenico Ghirlandaio (1449–94), you might miss her at first, since hers is not an individual portrait but a part of a tribute to the Tornabuoni family who commissioned the cycle. But once you see her, you can't look away. She is a visitor in *The Birth of the Virgin*. The setting, however, is not some humble residence in Galilee but a glamorous fifteenth-century Florentine palazzo. Behind her are a number of older women, modestly dressed and veiled. But she is gorgeous, a meltingly lovely profile and a body dressed to impress in the latest fashions of the day: a perfect example of the Platonic idea that physical beauty on the outside reflects spiritual beauty within.

I'd been thinking a lot about young women in fifteenth-century Florence when I came upon her. My novel *The Birth of Venus* was still in miserably inchoate form. I was grappling with how to recreate the experience of the cultural revolution that was the Florentine Renaissance by making it feel 'modern' rather than 'historical'. I was fascinated by women of the time, who barely figure in the roll-call of the powerful and artistically famous. What were their lives like? Their aspirations? Their choices? Like

all writers I was looking for a way into character, and that fashionable blonde got my imaginative juices flowing. Her dress alone is social history; so accurately painted that costume designers can reproduce the fashion by copying these portraits. In fact, this single fresco of figures gave me, the novelist, a sense not just of history but also of perspective – not least literally, of course, since this is the moment when art was luxuriating in its ability to make two dimensions feel like three.

In ten years of fictionalising the Renaissance I've studied thousands of images of men and women, some starring in their own stories, others extras in someone else's. The men were easier to 'read' than the women. But then society gave them more licence to be themselves: confident, idiosyncratic figures to be reckoned with regardless of looks. Women's individuality was harder to penetrate; Platonic beauty and the demands of Christian purity often made them appear more docile than dynamic.

On the other hand, away from the church walls, something quite daring was happening to women in paint: they were starting to take off their clothes for the overt enjoyment of men. Official history gives a writer little help when it comes to what goes on in the bedroom, but the story of Renaissance art, from the terrible

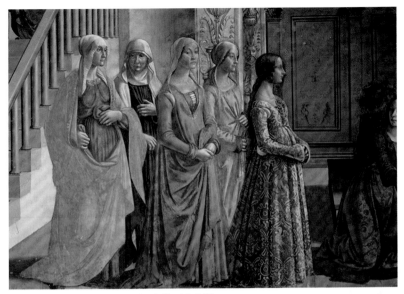

The Birth of the Virgin (detail) by Domenico Ghirlandaio, 1490
Fresco

shame of Eve, through *The Birth of* – a still coy – *Venus*, to the cool insouciance of the courtesan model of the *Venus of Urbino* by Titian (1485–1576), is a whole socio-sexual journey in itself; gold-dust for the novelist.

The move from religious to secular art was, of course, partly to do with the emergence of humanism, but in terms of the portrait it worked both ways. If men and women stood closer to God, then God also became more human.

In the history of Western portraiture there is no face more instantly recognisable than that of Jesus Christ: broad forehead, long, curling hair, fine nose, clear eyes and short beard, his features apparently captured on the Veil of St Veronica and described in a letter (later acknowledged to be

a fake) from the governor of Judea. The most distinct version comes not in paint but through the technical virtuosity of a seventeenth-century French engraver, Claude Mellan (1598–1688), executed by means of an unbroken spiral line. Before mass media and advertising, the power of this face is unassailable.

And not only the face… I've just finished a novel set in a sixteenth-century Benedictine convent and have spent a small eternity trying to understand how women's spiritual journeys, as well as some of their sexual ones (fifty per cent of all noble Italian women were nuns, whether they chose to be or not), were affected by increasingly lifelike portraits and sculptures of a semi-naked body, in a perfect state of manhood, hanging from a cross.

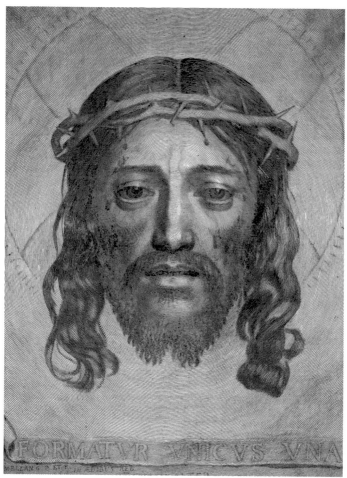

The Sudarium, or *Veil of St Veronica* by Claude Mellan, 1649
Engraving, 428 x 315mm (16⁷⁄₈ x 12⁵⁄₈")

You'd be amazed how different portraits of that body can be: from Grünewald's agonised, emaciated Christ of the altarpiece in the monastery at Isenheim, through the handsome, dignified figure in Brunelleschi's crucifix, to the tender young body attributed to Michelangelo in Florence in the early 1490s.

Interestingly, the reason Michelangelo's Christ is depicted as a young man is because it seems that was what he was; a youth, recently dead, delivered to the back of the church of Santo Spirito, where Michelangelo and others were engaged in night-time dissections. Artists, not content with making God more human, were trying get under the skin.

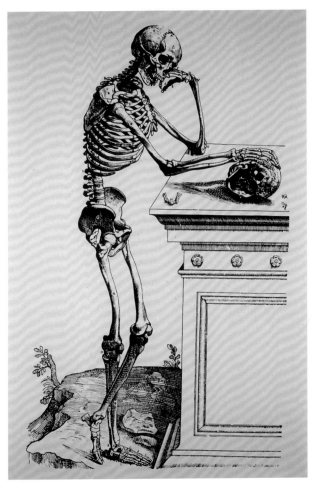

Engraving from the first edition of *De Humani Corporis Fabrica*
(On the Structure of the Human Body) by Andreas Vesalius, published in 1543
Engraving, 505 x 380mm (19$^7/_8$ x 14$^7/_8$")

That's the other thing that makes the Renaissance so irresistible to me as a contemporary writer: there is no other moment in art history – until today – when art and science are such creative partners.

For a time it was virtually a relay race. Though the great anatomical drawings of Leonardo da Vinci remain hidden in his notebooks, the baton of dissection moves between artists and men of medicine. So it's perhaps not surprising that by the time that other quintessential Renaissance man Andreas Vesalius (1514–64), who does both the dissection and the fabulous illustrations, publishes the first edition of *De Humani Corporis Fabrica* in 1543, his skeletons stand

and posture as if they were indeed portraits with their flesh stripped off, reminders of the personalities that they might once have been. Reminders also that even if you are rich enough to employ a painter to give you immortality, the end is the same. 'Alas, poor Yorick…' of the soul there is no trace.

Fast-forward five centuries and, while much has changed, much has also remained the same. Take women, for instance: though feminism may have caused its own cultural revolution, it is alarming how many (or shall we tell the truth here? – most) women still find themselves in thrall to the demands of looks over character.

We no longer buy into the Platonic notion of beauty within and without reflecting each other, but we appear to have signed up to a new belief system: one which tells us that if we are not happy with how we look (and dissatisfaction is how everything is sold to us) we can always change it. Straighten our noses, inflate – or deflate – our breasts, suck the fat out of our stomachs and legs, even strip the skin off the face and re-attach it a little bit tighter. You can almost see Vesalius, eyes as big as saucers, with his pencil at the ready.

And if that doesn't work then we can have a word with the artist – these days more often the photographer – to airbrush or photoshop the result. Photography, which began by giving paint a run for its money because of its capacity to capture reality as opposed to just impression, has fast become the court painting of its day (remember Henry VIII and the portraits of Anne of Cleves?).

Enter the modern portrait. Take a wander though the recent acquisitions in the National Portrait Gallery and you'll see what I mean. Possibly in reaction to a world saturated with altered images, contemporary portrait painters are in pursuit of deeper, more subversive kinds of beauty. And, like their Renaissance counterparts, they're interested in getting under the skin. It takes courage to fly in the face of the current body fascism, which is why two of my favourite paintings in the Gallery are by, and of, women.

Germaine Greer can have had no illusions when, in 1995, she entered the studio of Paula Rego (b.1935). Flattery was never going to be the name of the game. Nevertheless, Rego's unflinching gaze is almost shocking. Greer comes across as an ageing – older than she was at the time – eccentric, obstreperous figure. But that, of course, is exactly what is so marvellous about it. She is! And neither of them was afraid to show it. As that splendid, irascible intelligence grows older, she seems to fit her portrait even better. Like the inverse of Dorian Gray.

Then there is the painting of Fiona Shaw, the work of BP winner Victoria Russell (b.1962). For my money this is a monumental painting: a woman half dressed, an actress getting ready to become someone else, and yet still so much herself. It is a psychological study of huge depth, both vulnerable and powerful at the same time: personality, reality, illusion all in one.

Finally, there is the very recent (2008) portrait of Sir Paul Nurse. You don't

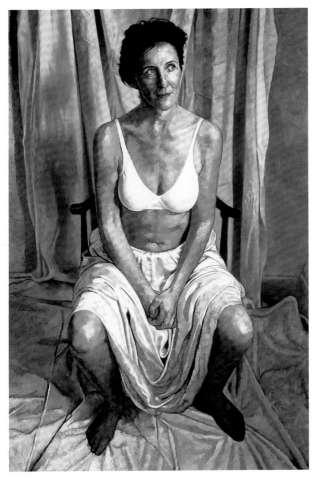

Fiona Shaw (b.1958) by Victoria Russell, 2002 (NPG 6609)
Oil on canvas, 1828 x 1220mm (72 x 48")

know him, perhaps? Neither, I am ashamed to say, did I. He is a biochemist and a Nobel Prize winner, whose groundbreaking work on cancer looks at genomic and post-genomic approaches to the way DNA replication is controlled in cells. In other words, the bits of the body that even the sharpest-eyed artists can never see. But art has never shirked a challenge and one of the most

exciting things about contemporary culture is the conversation now going on between art and science over the body and the brain, and where life meets death. (Think about the best of Damien Hirst, or the collaborations between artists and the brain-imaging neuroscientist Mark Lythgoe.)

Enter Jason Brooks (b.1968), the man who painted Sir Paul Nurse.

13

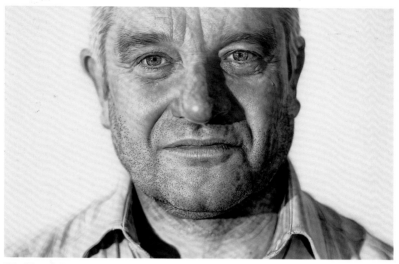

Sir Paul Nurse (b.1949) by Jason Brooks, 2008 (NPG 6837)
Acrylic on linen, 1710 x 2710mm (67⅜ x 106¾")

Working together, these two have produced something that I think mirrors those Renaissance artists peeling back the skin to try to see what is underneath. The bad news is that you won't see much of this in the reproduction you are looking at. Such is the depth of the photorealism in the painting that every one of those brush strokes is just too fine for you to see: not unlike the millions of cells inside us, invisible to the naked eye. The good news is that if you go to the Gallery the portrait will hit you like a freight train, not least because it's placed in a corridor, so you are positively forced to look closer. When you do, you are in for a treat.

The man himself is there for all to see: a striking, well-lived-in face, at ease with itself, a shining, open intelligence in the eyes. But the closer you get, the less you see him and the more you see what he is made up of – in this case an infinity of dots and brushstrokes. And the more you see, the more it is an invitation for going further, up through the nose, between the lips, in through the back of an eye. It's like an opening shot for *Fantastic Voyage* (1966), that movie where humans get shrunk and travel through someone's body, a deep-sea adventure through arteries and veins. Or in this case into the cells themselves.

Perhaps you think I am exaggerating, being rather… well, artistic. Possibly I am. However, having spent a decade trying to penetrate an equally inaccessible world, that of the past, I am only too aware that some of my most adventurous guides have been artists, eager to explore what it means to be human, both outside and in. It seems to me that the best of them are still trying to do exactly that.

Sarah Dunant
Author and Critic

BP PORTRAIT AWARD 2009

The Portrait Award, in its thirtieth year at the National Portrait Gallery and its twentieth year of sponsorship by BP, is an annual event aimed at encouraging artists to focus on and develop the theme of portraiture in their work. The competition is open to everyone aged eighteen and over, in recognition of the outstanding and innovative work currently being produced by artists of all ages working in portraiture.

THE JUDGES

Chair: Sandy Nairne,
Director,
National Portrait Gallery

James Holloway,
Director,
Scottish National Portrait Gallery

Charlotte Mullins,
Art Critic and Historian

Gillian Wearing,
Artist

THE PRIZES
The BP Portrait Awards are:

First Prize
£25,000, plus at the Gallery's discretion a commission worth £4,000 to paint a well-known person.
Peter Monkman

Second Prize
£8,000
Michael Gaskell

Third Prize
£6,000
Annalisa Avancini

BP Young Artist Award
£5,000
Mark Jameson

PRIZEWINNING
PORTRAITS

Changeling 2
Peter Monkman

Oil on canvas,
1220 x 900mm (48$\frac{1}{8}$ x 35$\frac{1}{2}$")

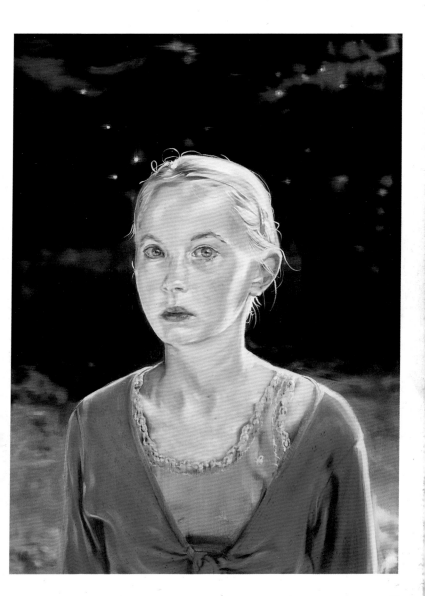

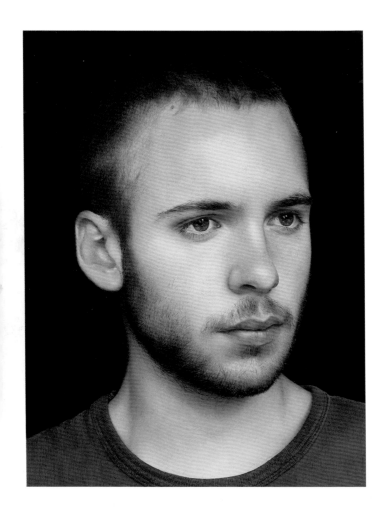

Manuel
Annalisa Avancini

Oil on canvas,
1000 x 800mm (39³/₈ x 31¹/₂")

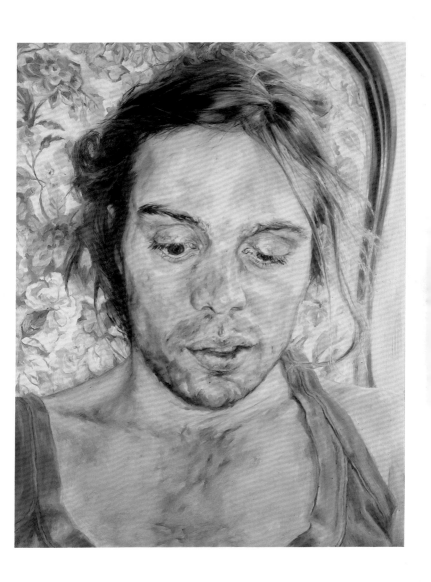

Benfica Blue
Mark Jameson

Oil and acrylic on linen,
1220 x 762mm (48$^{1}/_{8}$ x 29$^{7}/_{8}$")

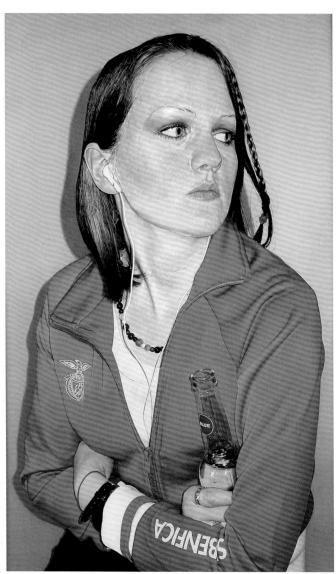

SELECTED
PORTRAITS

White Linen
Jennifer Anderson

Oil on canvas,
900 x 700mm (35$^{1}/_{2}$ x 27$^{5}/_{8}$")

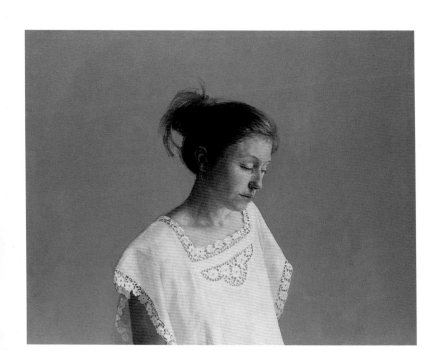

Georgie
Mary Jane Ansell

Oil on wooden panel,
344 x 216mm (13$^5/_8$ x 8$^1/_2$")

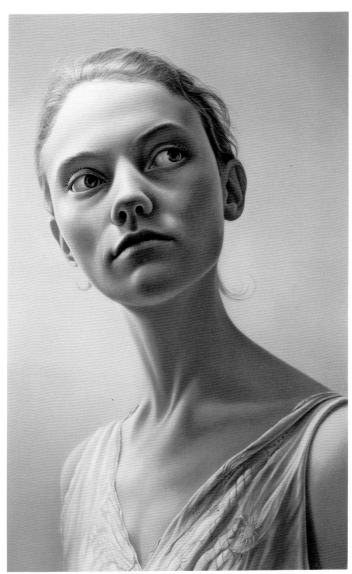

The Rt. Hon. Lord Poltimore,
Chairman of Sotheby's Russia and
Deputy Chairman of Sotheby's Europe
Elena Baranoff

Egg tempera on marble gesso board,
405 x 305mm (15⁷/₈ x 12")

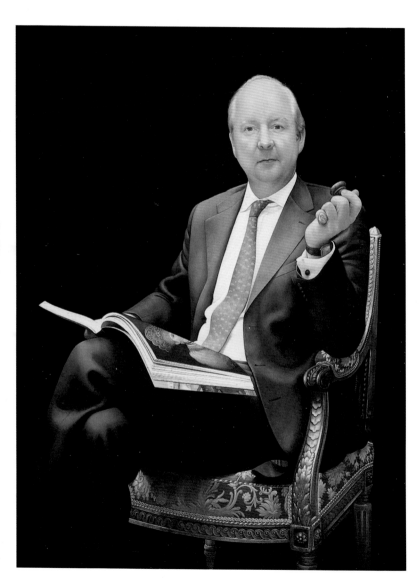

Debs
Matt Batt

Acrylic on canvas board,
457 x 356mm (18 x 14")

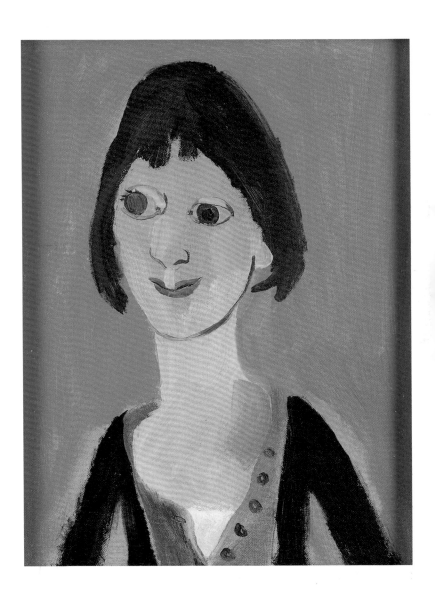

Amelia
Celia Bennett

Oil on canvas board,
440 x 310mm (17$\frac{1}{4}$ x 12$\frac{1}{8}$")

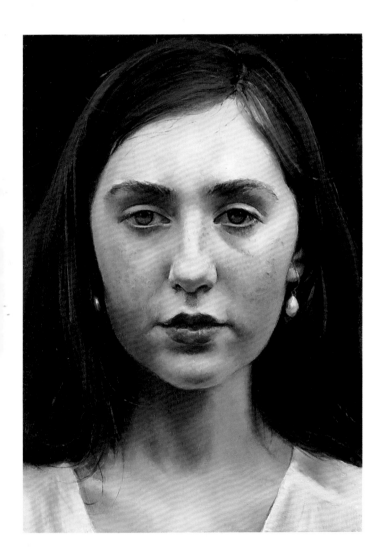

Dit is ek Gladys (It is me Gladys)
Shany van den Berg

Oil on wooden board,
700 x 900mm (27⁵/₈ x 35¹/₂")

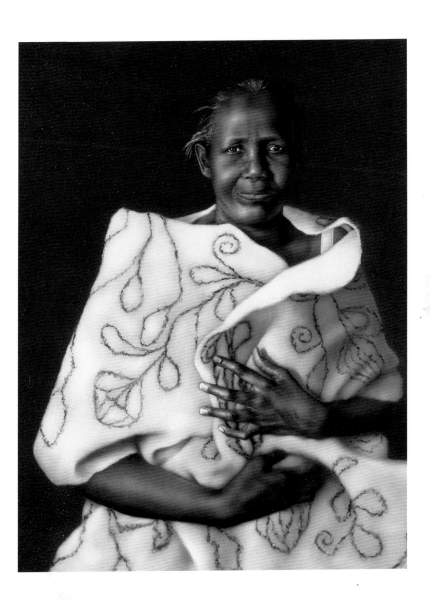

Portrait of my daughter Michelle
Carey Clarke

Oil on canvas,
1270 x 915mm (50 x 36")

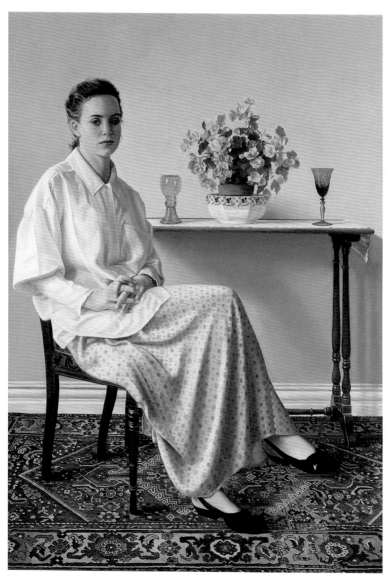

Robert
Mark Clay

Oil on wooden board,
400 x 280mm (15³/₄ x 11")

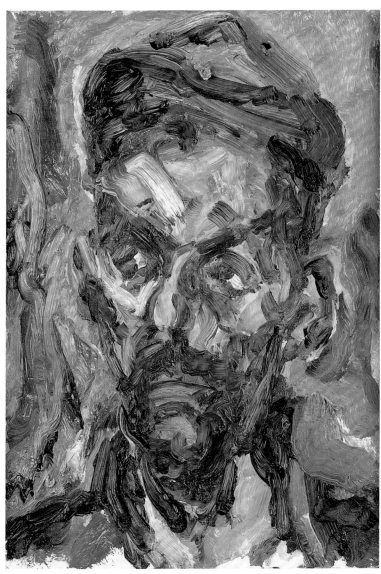

Madeleine
Jayne Cooper

Oil on canvas,
1524 x 1220mm (60 x 48$^{1}/_{8}$")

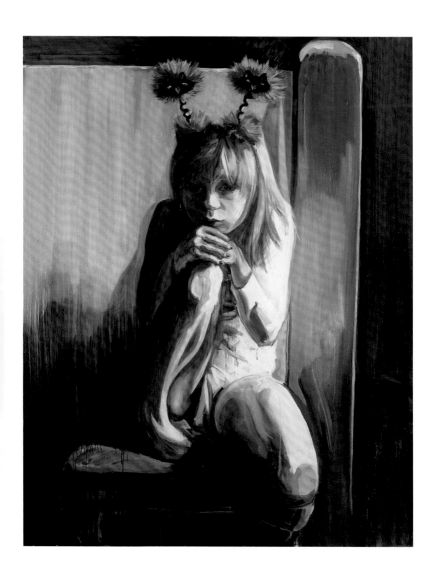

Imagine
José Luis Corella

Oil on wooden board,
1000 x 1000 mm (39$\frac{3}{8}$ x 39$\frac{3}{8}$")

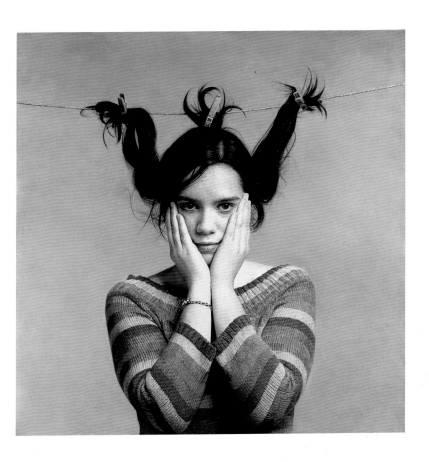

One in Two
Ian Cumberland

Oil on linen,
1000 x 700mm (39$^{3}/_{8}$ x 27$^{5}/_{8}$")

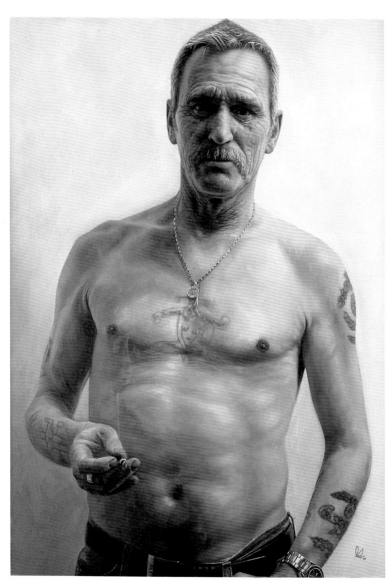

Iris
Clara Drummond

Oil on canvas,
400 x 500mm (15³/₄ x 19⁵/₈")

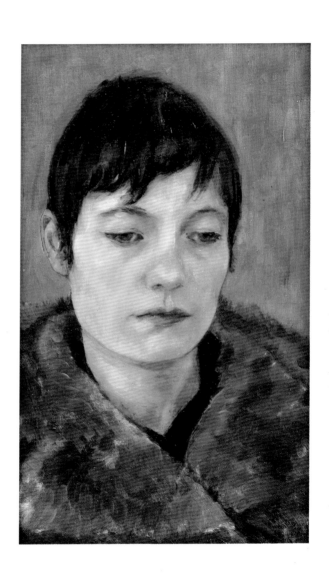

The Animal Handler
Ben Edge

Oil on canvas,
250 x 200mm (9⁷/₈ x 7⁷/₈")

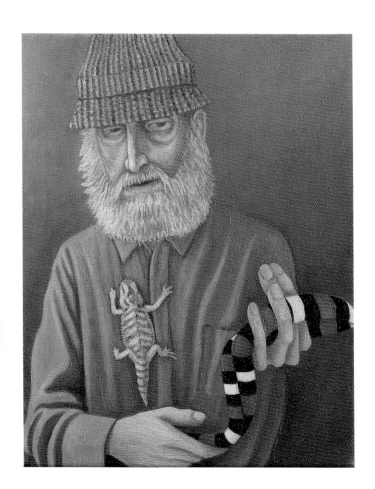

Guillem
Miriam Escofet

Oil on canvas on wooden board,
500 x 400mm (19⅝ x 15¾")

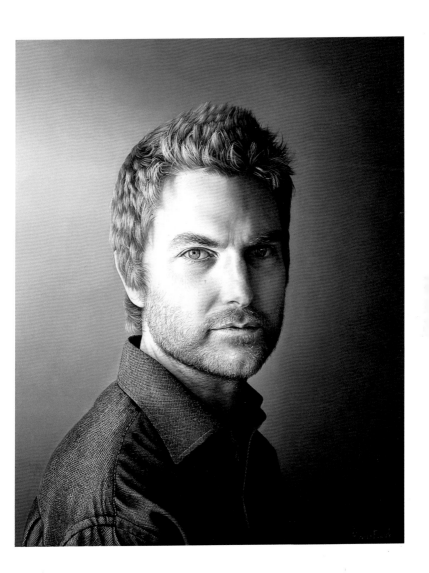

Gail Porter
Lee Fether

Oil on canvas,
800 x 600mm (31$^1/_2$ x 23$^5/_8$")

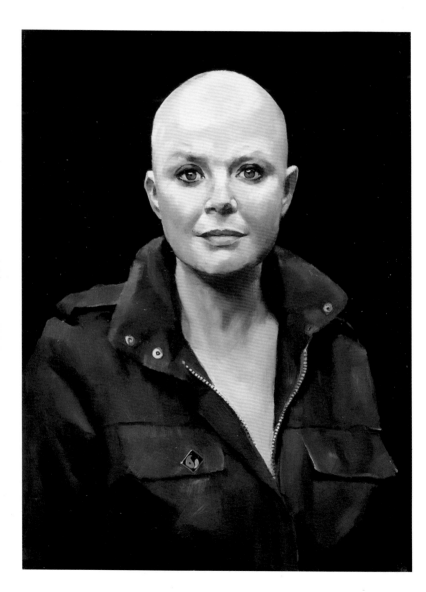

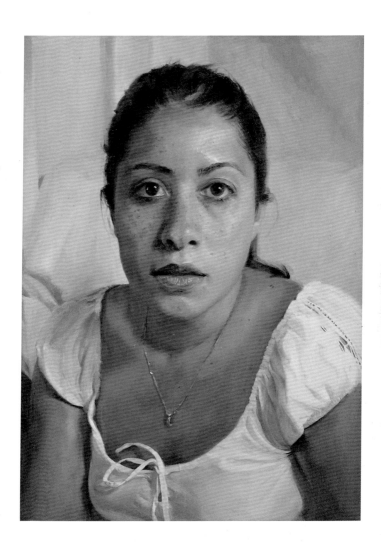

Woman ironing (my mother)
Ismael Fuentes

Oil on wooden board,
1140 x 1000mm (44$^{7}/_{8}$ x 39$^{3}/_{8}$")

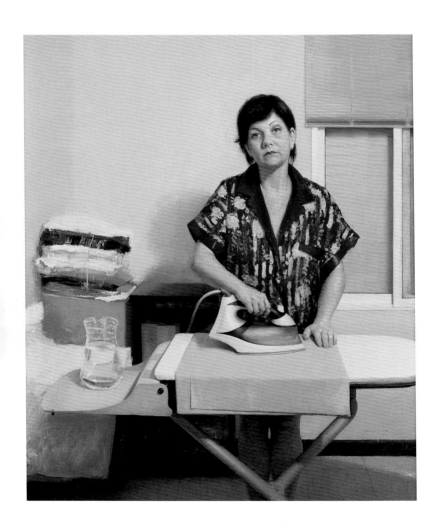

5am
Marianne L. Gibson

Oil on board,
270 x 220mm (10^5/$_8$ x 8^5/$_8$")

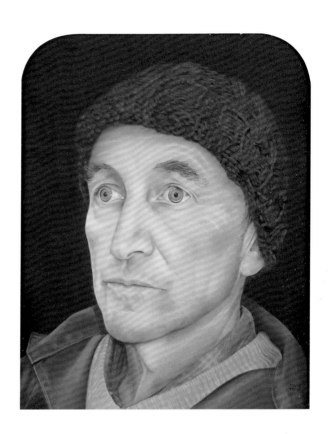

Brittani
June Glasson

Oil on wooden board,
300 x 400mm (11$^{7}/_{8}$ x 15$^{3}/_{4}$")

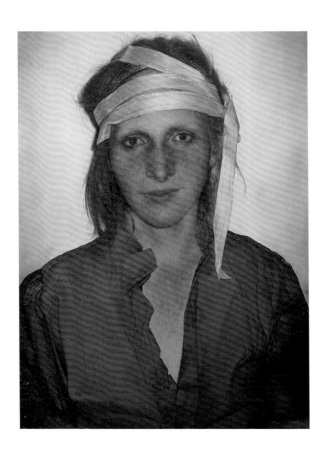

Autorretrato con camisa negra
(Self-portrait with black shirt)
Daniel González Coves

Oil on wooden board,
900 x 900mm (35$^{1}/_{2}$ x 35$^{1}/_{2}$")

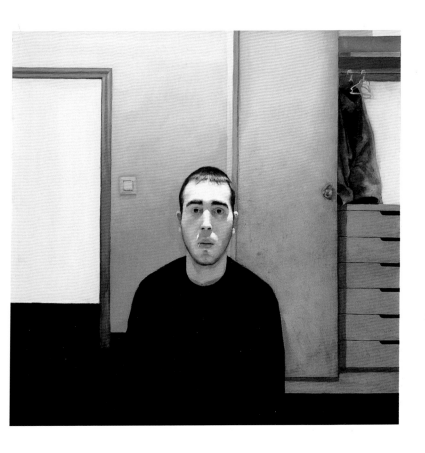

Portrait of my mother
Hector M. Hernandez

Oil on canvas,
356 x 914mm (14 x 36")

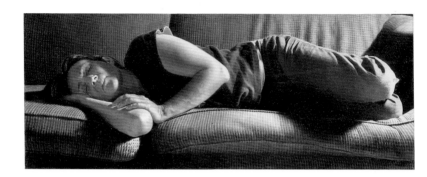

Lady Sainsbury of Preston Candover
(formerly Anya Linden, ballerina)
Eileen Hogan

Oil on board,
360 x 780mm (14$^{1}/_{8}$ x 30$^{5}/_{8}$")

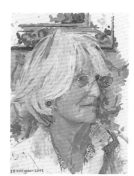
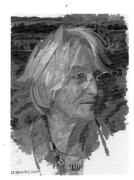

Agnes
Natalie Holland

Oil on canvas,
600 x 450mm (23$^{5}/_{8}$ x 17$^{5}/_{8}$")

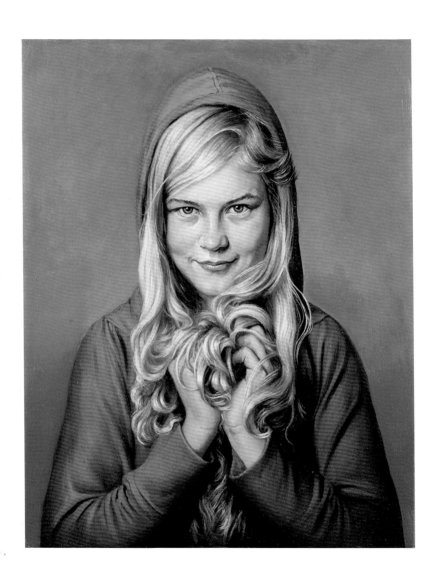

Oil on canvas,
460 x 360mm (18$^{1}/_{8}$ x 14$^{1}/_{8}$")

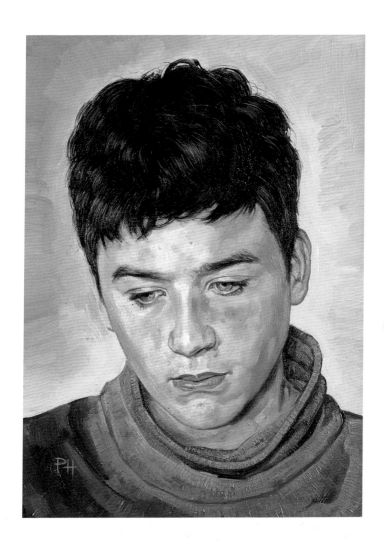

My Grandmother
Ho-Jun Lee

Oil on canvas,
250 x 200mm (9$^{7}/_{8}$ x 7$^{7}/_{8}$")

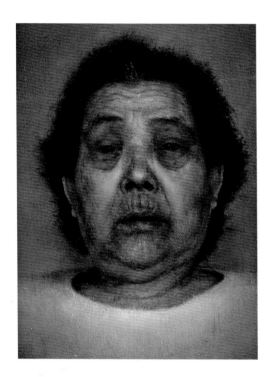

Fatema
Susan Light

Oil on linen,
1520 x 610mm (59$^{7}/_{8}$ x 24")

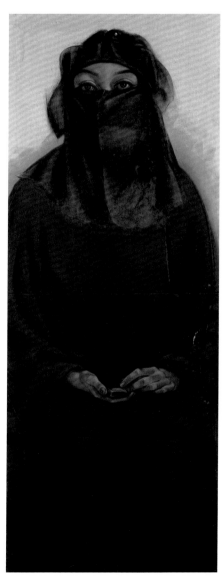

Harry Patch
Dan Llywelyn Hall

Oil and acrylic on canvas,
700 x 1000mm (27$^{5}/_{8}$ x 39$^{3}/_{8}$")

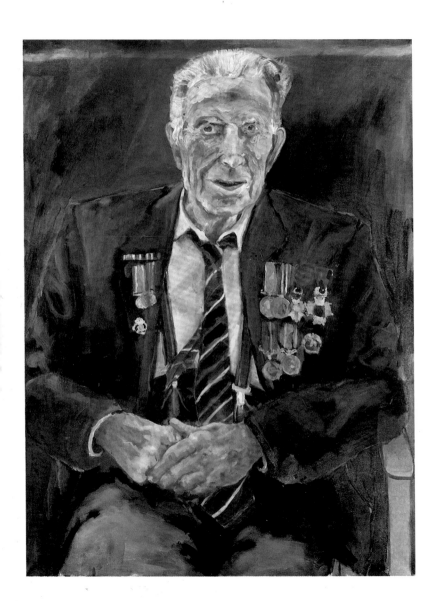

Dr Sameena Shakoor,
Consultant Paediatrician
Graeme Lothian

Oil on canvas,
500 x 710mm (19⁵/₈ x 27⁷/₈")

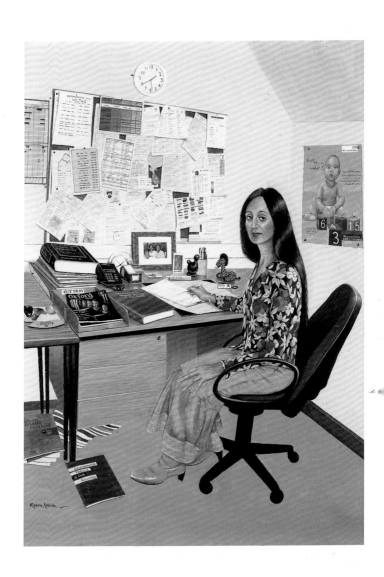

Oil on canvas,
700 x 500mm (27⁵/₈" x 19⁵/₈")

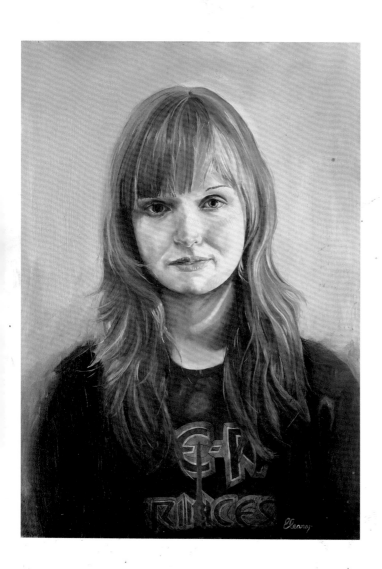

Broken heart
Donald Macdonald

Oil on canvas,
1100 x 900mm (43$\frac{1}{4}$ x 35$\frac{1}{2}$")

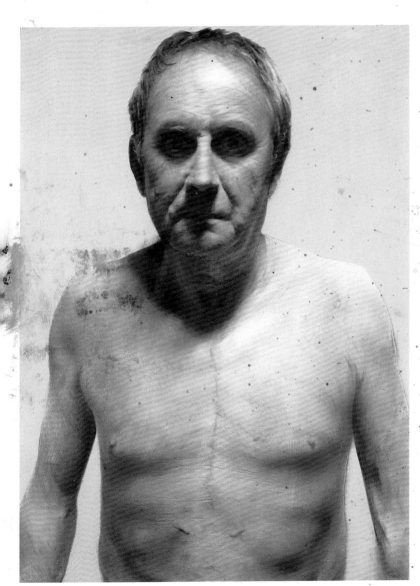

Movers and Shakers:
Pat and Geoffrey Eastop
Jennifer McRae

Oil on linen,
1520 x 1220mm (59$^7/_8$ x 48$^1/_8$")

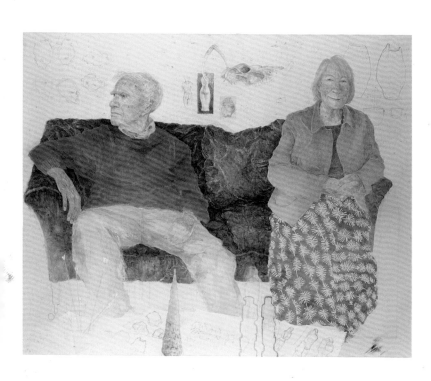

Angela from Sri Lanka
Hynek Martinec

Acrylic on canvas,
1200 x 1200mm (47$\frac{1}{4}$ x 47$\frac{1}{4}$")

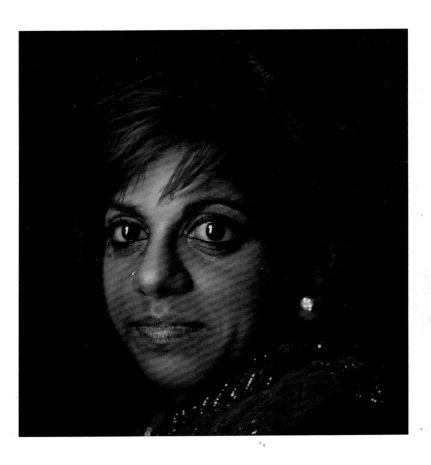

Gregor
James Metcalfe

Oil on linen,
355 x 305mm (14 x 12")

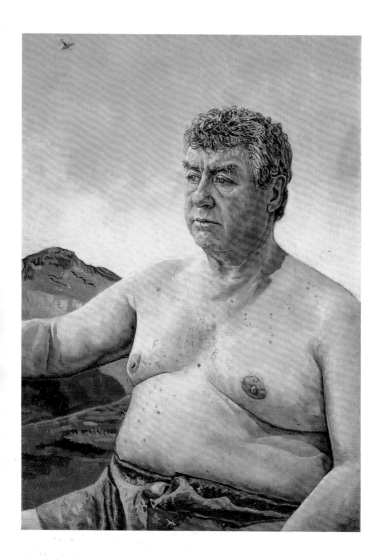

Oil on linen on board,
614 x 343mm (24$^{1}/_{8}$ x 13$^{1}/_{2}$")

Hats and Scarves
Tim Okamura

Oil on canvas,
2032 x 2235mm (80 x 88")

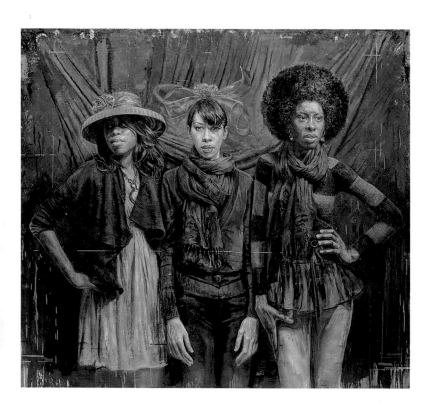

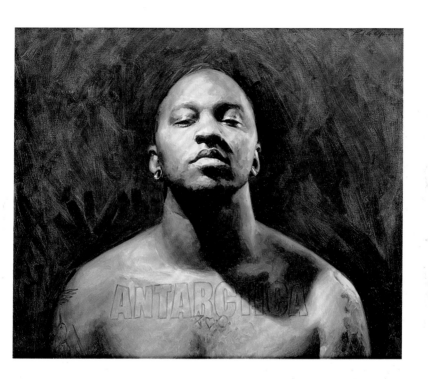

Ruth
Isobel Peachey

Oil on canvas,
900 x 600mm (35$^1/_2$ x 23$^5/_8$")

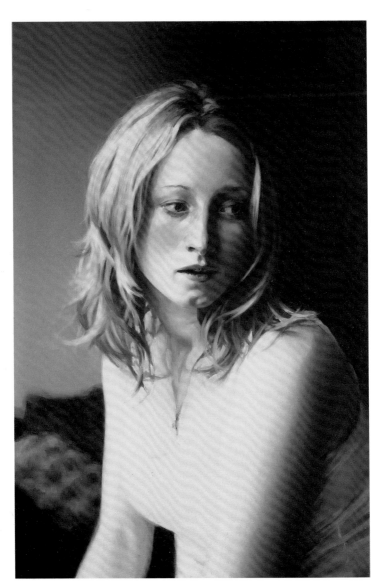

Eva
Natan Pernick

Oil on canvas,
800 x 600mm (31$^{1}/_{2}$ x 23$^{5}/_{8}$")

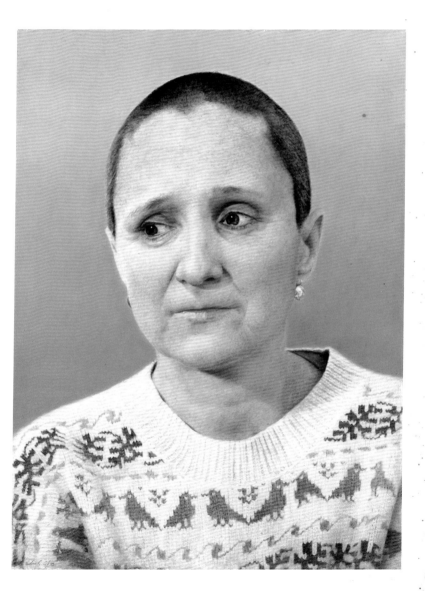

Kate
Anastasia Pollard

Oil on board,
280 x 200mm (11 x 7$^{7}/_{8}$")

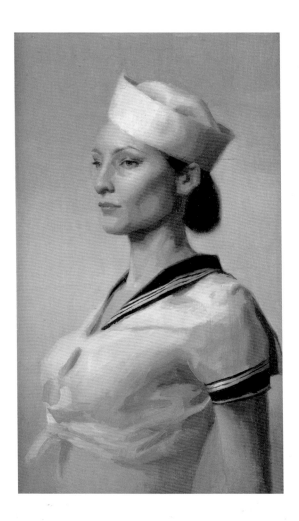

Philip and Joe
(Grandfather and Grandson)
Philip Renforth

Oil on board,
1250 x 950mm (49$^{1}/_{8}$ x 37$^{3}/_{8}$")

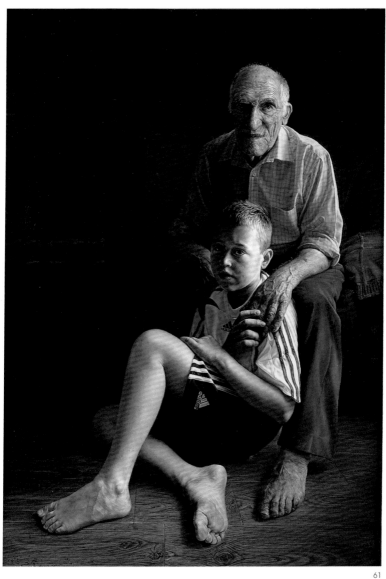

Oil on canvas,
203 x 203mm (8 x 8")

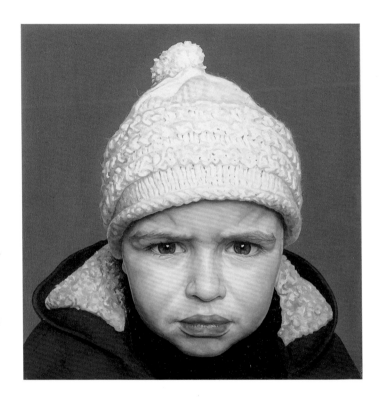

Maggie
Sue Rubira

Oil on canvas,
1020 x 760mm (40$^{1}/_{8}$ x 29$^{7}/_{8}$")

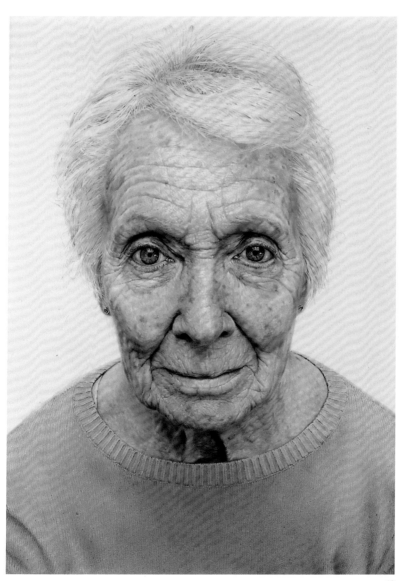

John Anthony Portsmouth
Football Club Westwood
Karl Rudziak

Oil on canvas,
1200 x 2000mm (47$^{1}/_{4}$ x 78$^{3}/_{4}$")

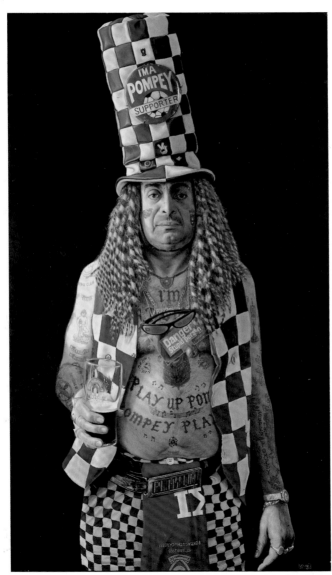

Grandmother
SACRIS

Oil on canvas,
1525 x 1980mm (60$^1/_8$ x 77$^7/_8$")

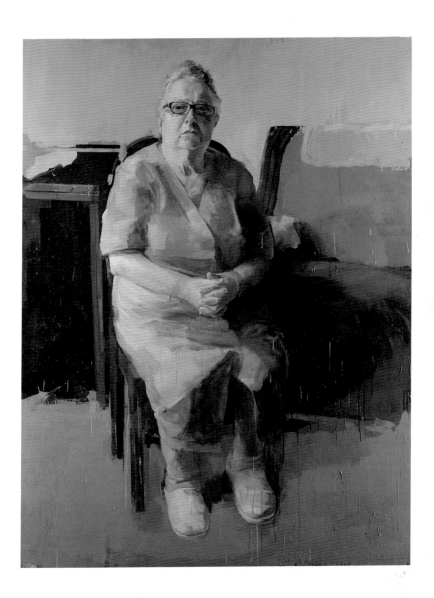

George
Louis Smith

Oil on canvas,
550 x 700mm (21$^{5}/_{8}$ x 27$^{5}/_{8}$")

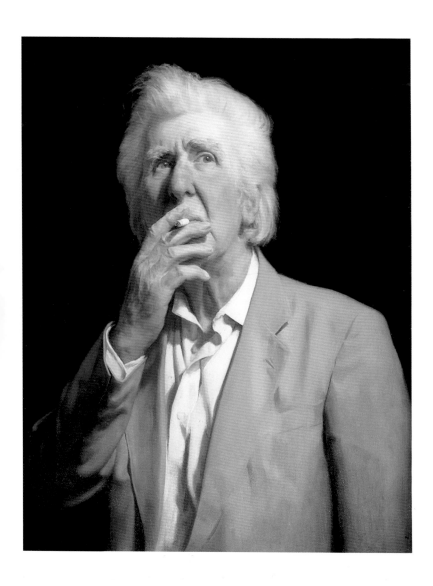

My song
Jung-Im Song

Oil on canvas,
610 x 455mm (24 x 17⁷/₈")

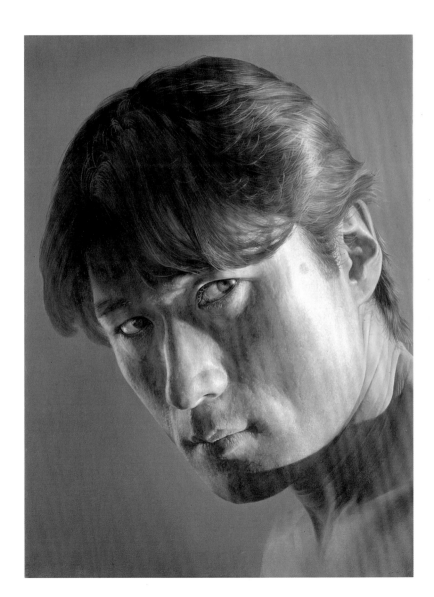

Life
Benjamin Sullivan

Oil on canvas,
1060 x 510mm (41³/₄ x 20¹/₈")

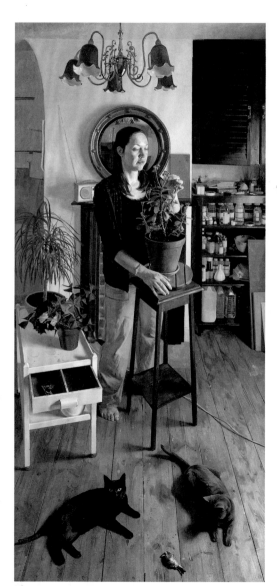

On Assi Ghat
Edward Sutcliffe

Oil on canvas,
550 x 400mm (21⁵/₈ x 15³/₄")

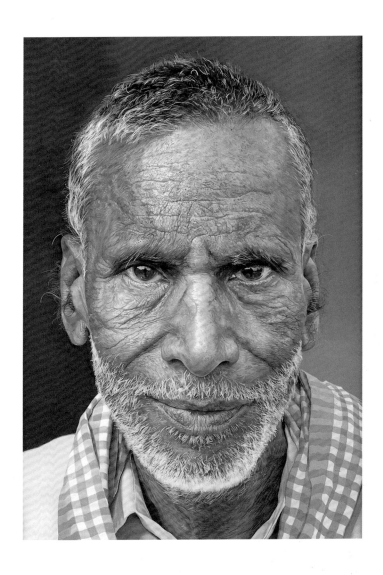

Francis
Mieke Teirlinck

Oil on canvas,
400 x 400mm (15$^{3}/_{4}$ x 15$^{3}/_{4}$")

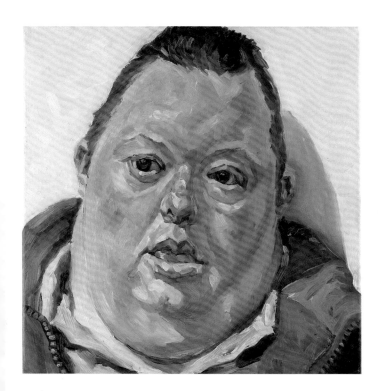

Lord Armstrong of Ilminster
Daphne Todd

Oil on wooden panels,
760 x 480mm (29$^{7}/_{8}$ x 18$^{7}/_{8}$")

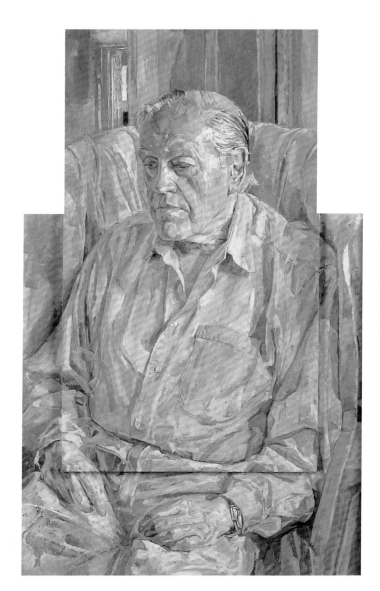

Virginia
Erin Wozniak

Oil on muslin on board,
267 x 204mm (10$^1/_2$ x 8$^1/_8$")

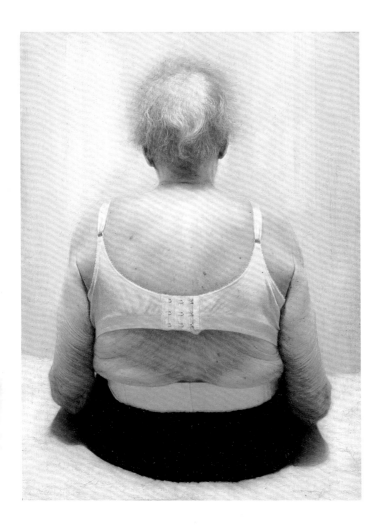

Mother
William Wright

Oil on board,
305 x 254mm (12 x 10")

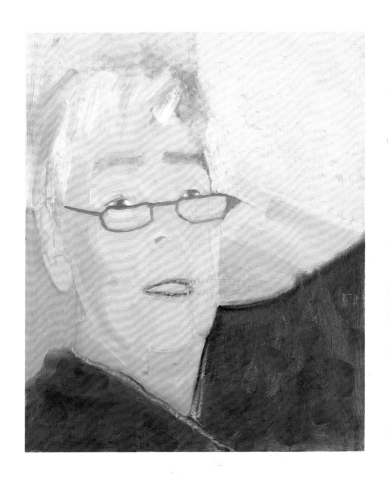

BP TRAVEL AWARD 2008

Each year exhibitors are invited to submit a proposal for the BP Travel Award. The aim of the award is to give an artist the opportunity to experience working in a different environment, in Britain or abroad, on a project related to portraiture. The artist's work is then shown as part of the following year's BP Portrait Award exhibition and tour. Last year, for the first time, we asked for submissions for the 2008 Award to be based only in China. The National Portrait Gallery and BP decided to make this link with China to celebrate the hosting of the 2008 Olympic and Paralympic Games in Beijing, and the China Now festival, which took place in the UK in 2008.

THE JUDGES

Sarah Howgate,
Contemporary Curator,
National Portrait Gallery

Liz Rideal,
Art Resource Developer,
National Portrait Gallery

Des Violaris,
Director, UK Arts & Culture, BP

The Prizewinner 2008
Emmanouil Bitsakis, who received £5,000 for his proposal to travel to north-west China to paint portraits of the national minority of Uigur people.

FACES OF THE UIGUR THROUGH SONG & DANCE

In October 2008 I visited the Xinjiang Uigur Autonomous Region of north-west China to isolate from the vastness of the country the 'faces' of a minority culture that is Chinese and yet does not appear to be so. Among the thirteen different ethnic communities that live in the Region, the national minority of Uigur predominate, though in population they are declining. The Uigur remain culturally distinct from the majority Han Chinese and are the far-eastern branch of the extended family of Turkic peoples, who live in an immense region that extends throughout Central Asia. Originally Buddhist, they converted to Islam around the tenth century. Apart from their religion, their exceptional music and dance idiom, 'Muqam', is the core of their identity and culture.

After a five-day stay in Beijing, and while waiting in the airport for the morning flight to Urumqi, I came across the first 'non-Chinese' citizens of the People's Republic of China, the Uigur. It was a pleasant surprise to be able to listen to and grasp a few words of a relatively familiar language because, as part of the preparation for this trip, I had tried to familiarise myself with the Uigur dialect, which belongs to the Turkic branch of the Altaic languages. In a small notebook I wrote down ways in which the Uigur idiom resembles or differs from Turkish – a language I already speak. This notebook, in which the lives and habits of the Uigur were recorded throughout my journey, also became my main sketchbook as I began to illustrate my notes with drawings of these unique people.

My arrival in Urumqi was an exciting experience. The capital of the Xinjiang Uigur Autonomous Region gives the impression of an emerging metropolis, with towering skyscrapers

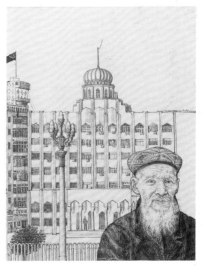

An aged man with a public building of the Uigur Autonomous Region in the background by Emmanouil Bitsakis, 2008
Pen on paper, 145 x 105mm (5⅝ x 4⅛")

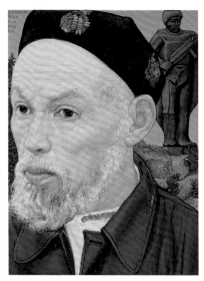

Portrait of an old man by Emmanouil Bitsakis, 2008
Oil on canvas, 125 x 90mm (4⁷/₈ x 3⁵/₈")

(a building that imitates the famous Chrysler building in New York is the pride of the city), enormous avenues and colossal flyovers. There, the Uigur neighbourhoods can be traced.

The Uigur people – clearly distinct from the Han Chinese – are dark-skinned, dark-eyed and sturdy, with features that allude to Central Asia or the Middle East. Women combine disparate clothes, but in an inspired way with brave colour contrasts. Their creativity transforms the traditional Muslim headscarf into an exceptionally recognisable accessory. Contrary to the friendly disposition of the middle-aged and elder women, young women are not very approachable so I spoke to them only when they expressed a wish to see my sketchbook, but always with some shyness. In order to be able to take pictures to use as studies for portraits of them I had

to be resourceful: I used to walk up Hongshan Park, which is a favourite promenade for families and young couples. There, taking advantage of the fact I was a tourist, I pretended to photograph the statue of a Chinese official while I was actually taking pictures of young women.

Men are usually dressed in old-fashioned grey, blue or black loose-fitting suits. As they walk briskly their fine physique is outlined through graceless and bulky outfits. Unlike the women, men will approach to find out who you are and what you are doing in their country. My efforts to speak their language were received with enthusiasm.

When I asked men to pose for a picture they responded eagerly: they put their hats on and puffed up with pride in front of the camera. If someone perceived he was being sketched he would promptly make suggestions on how he wished his features rendered. On the other hand, one time when I attempted to sketch a woman in a local restaurant, I immediately attracted people's attention and there was a rather unpleasant fuss about it, while the woman looked really uncomfortable with the whole situation. When her husband came and she explained to him what was going on, he gave me a hostile stare. Surprisingly, when I checked out with them what was the issue, they both thanked me politely.

The Uigur's socialisation and courtesy do have limits, though, especially in the capital, where the population of the Han Chinese is increasing rapidly due to constant migration. In towns

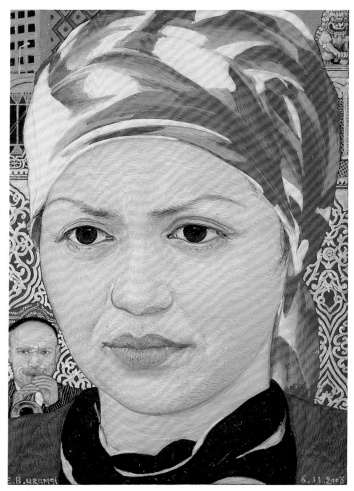

Portrait of a young woman by Emmanouil Bitsakis, 2008
Oil on canvas, 125 x 90mm (4⁷/₈ x 3⁵/₈")

such as Kashgar and Turpan, where the Uigur population is dense, the people's initial openness and affability are enhanced by their familiarisation with foreigners due to developing tourism. These areas attract tourists because of renowned music festivals, significant Muslim monuments and the unique Uigur culture within the framework of the vast Chinese motherland. The downside of this progress, however, is that the Uigur risk losing their authenticity and spontaneity by exploiting their culture as a tourist attraction.

A collection of songs and instrumentals known as 'Twelve Muqams', whose origin goes back to

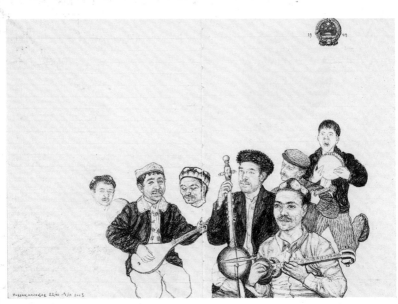

Singing and playing music Uigur by Emmanouil Bitsakis, 2008
Pen on paper, 145 x 210mm (5⁵/₈ x 8¹/₄")

the sixteenth century, epitomises the traditional music of the Uigur. 'Twelve Muqams' runs for more than twelve hours and includes a variety of proverbs or poems set to music, unique dancing rhythms and figures, and involves around fifteen wind and bowed or plucked string instruments. Traditional Uigur music can be heard at all social gatherings and, apart from annual festivals, a high number of music and dance performances are staged in restaurants and public places. Furthermore, musicians may be hired by department stores as a roadside advertising attraction. Occasionally, shopkeepers may play music during their lunch break. In Renmin Gongyuan Park in Urumqi, Han Chinese and Uigur jointly attend open-air lessons of Uigur traditional dance. Even during rush-hour traffic jams, Uigur men in open-carriage trucks play their music and dance

while thousands of commuters pour out of nearby streets and markets. Although the traditional Uigur music is kept alive, it is difficult nowadays to adhere to the old masters' tradition and thus the 'Muqam' technique is gradually being lost.

Despite the fact that the Uigur live on the margins of the radical economic, political and social changes that are taking place in the People's Republic of China, this culturally distinct Turkic tribe with its long history is struggling against assimilation by the Han Chinese, whose domination within the Xinjiang Uigur Autonomous Region is becoming more evident.

Emmanouil Bitsakis

ACKNOWLEDGEMENTS

My first thanks go to all the artists – and an increasing number from overseas – who made the decision to enter the BP Portrait Award 2009. Particular congratulations go to the artists included in the exhibition, and special praise for the prizewinners – Peter Monkman, Michael Gaskell and Annalisa Avancini, and to Mark Jameson, the winner of the prize for a younger painter.

Many thanks go to my fellow judges: James Holloway, Charlotte Mullins, Gillian Wearing and Des Violaris. They brought sharp eyes to this large field of entries, and rigour and humour to the selection process. I am also grateful to the judges of the BP Travel Award 2009: Flora Fricker, Liz Rideal and Des Violaris. I would like to offer particular thanks to Sarah Dunant for her fascinating catalogue essay, which links contemporary portrait painting back to the traditions of the Renaissance. I am very grateful to Claudia Bloch for her editorial work, to October Design for designing the catalogue, to Flora Fricker for her creative management of the BP Portrait Award 2009 exhibition and to Pim Baxter, Deputy Director and Director of Communications and Development, for her continuing contribution to the whole project. My thanks also go to Rosie Broadley, Denise Dean, Andrea Easey, Denise Ellitson, Ian Gardner, Michelle Greaves, Celia Joicey, Eleanor Macnair, Ruth Müller-Wirth, Jonathan Rowbotham, Jude Simmons, Liz Smith, Sarah Tinsley and other colleagues at the National Portrait Gallery for all their hard work in making the project such a continuing success. I am also grateful to the white wall company for their contribution during the selection and judging process.

Sandy Nairne
Director, National Portrait Gallery

INDEX

Anderson, Jennifer 22
Ansell, Mary Jane 23
Avancini, Annalisa 19 (Third prize)

Baranoff, Elena 24
Batt, Matt 25
Bennett, Celia 26
Berg, Shany van den 27
Bitsakis, Emmanouil: 75–9
 An aged man 75
 Portrait of an old man 76
 Portrait of a young woman 77
 Singing and playing music Uigur 78
Brooks, Jason: Sir Paul Nurse 12–14, 14

Clarke, Carey 28
Clay, Mark 29
Cooper, Jayne 30
Corella, José Luis 31
Cumberland, Ian 32

Drummond, Clara 33

Edge, Ben 34
Escofet, Miriam 35

Fether, Lee 36
Foroozanfar, Maryam 37
Fuentes, Ismael 38

Gaskell, Michael 18 (Second prize)
Ghirlandaio, Domenico: The Birth of the Virgin 8, 9
Gibson, Marianne L. 39
Glasson, June 40
González Coves, Daniel 41
Greer, Germaine 12

Hernandez, Hector M. 42
Hogan, Eileen 43
Holland, Natalie 44
Holt, Peter 45

Jameson, Mark 20 (BP Young Artist Award)

Lee, Ho-Jun 46
Light, Susan 47
Llywelyn Hall, Dan 48
Lothian, Graeme 49

McCaughey, Eleanor 50
Macdonald, Donald 51
McRae, Jennifer 52
Martinec, Hynek 53
Mellan, Claude: The Sudarium,
 or Veil of St Veronica 9, 10
Metcalfe, James 54
Monkman, Peter 17 (First prize)

Nipo, David 55
Nurse, Sir Paul 12–14, 14

Okamura, Tim 56
Oxborough, Paul 57

Peachey, Isobel 58
Pernick, Natan 59
Pollard, Anastasia 60

Rego, Paula: Germaine Greer 12
Renforth, Philip 61
Rogers, Stephen Earl 62
Rubira, Sue 63
Rudziak, Karl 64
Russell, Victoria: Fiona Shaw 12, 13

SACRIS 65
Shaw, Fiona 12, 13
Smith, Louis 66
Song, Jung-Im 67
Sullivan, Benjamin 68
Sutcliffe, Edward 69

Teirlinck, Mieke 70
Todd, Daphne 71

Vesalius, Andreas: De Humani
 Corporis Fabrica 11, 11–12

Wozniak, Erin 72
Wright, William 73